ISSUE #1

L'AMOUR FOU

a journal of the surreal

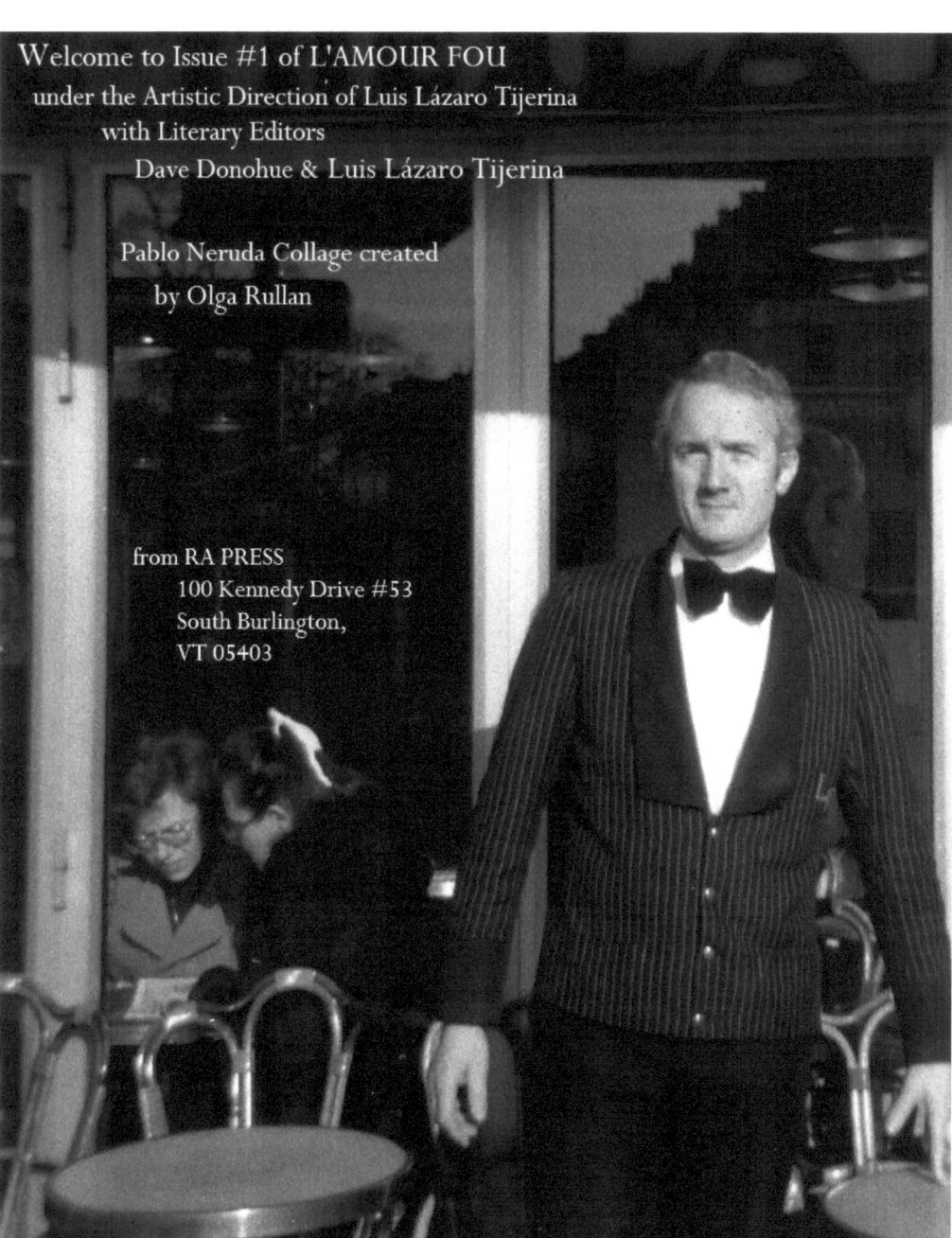

Welcome to Issue #1 of L'AMOUR FOU
under the Artistic Direction of Luis Lázaro Tijerina
with Literary Editors
Dave Donohue & Luis Lázaro Tijerina

Pablo Neruda Collage created
by Olga Rullan

from RA PRESS
100 Kennedy Drive #53
South Burlington,
VT 05403

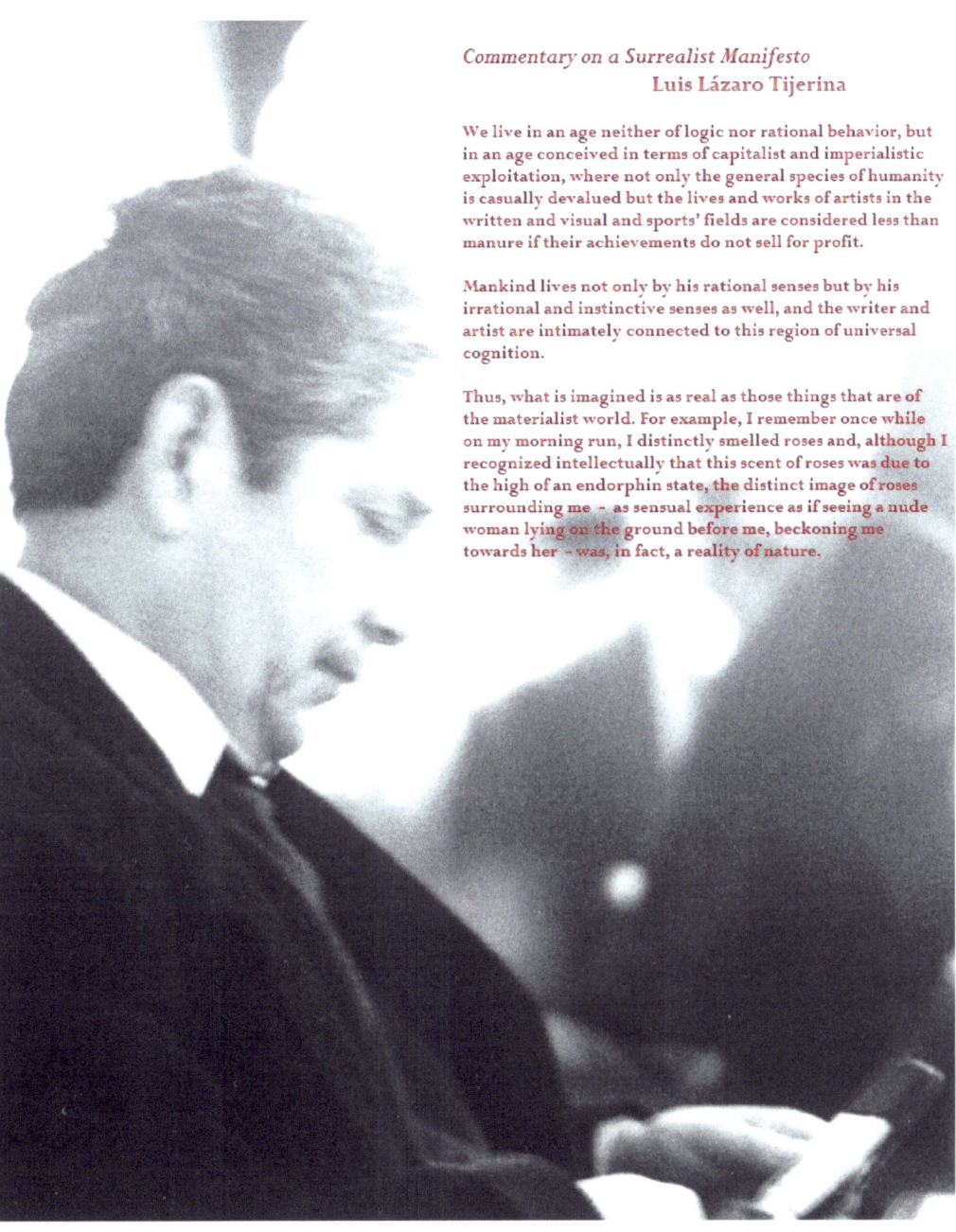

Commentary on a Surrealist Manifesto
Luis Lázaro Tijerina

We live in an age neither of logic nor rational behavior, but in an age conceived in terms of capitalist and imperialistic exploitation, where not only the general species of humanity is casually devalued but the lives and works of artists in the written and visual and sports' fields are considered less than manure if their achievements do not sell for profit.

Mankind lives not only by his rational senses but by his irrational and instinctive senses as well, and the writer and artist are intimately connected to this region of universal cognition.

Thus, what is imagined is as real as those things that are of the materialist world. For example, I remember once while on my morning run, I distinctly smelled roses and, although I recognized intellectually that this scent of roses was due to the high of an endorphin state, the distinct image of roses surrounding me – as sensual experience as if seeing a nude woman lying on the ground before me, beckoning me towards her – was, in fact, a reality of nature.

BOURGEOIS LOVE

You and I, my love,
have agreed to enthrone ourselves upon this bed of sex
as morning comes falling from the sky.
Open lips, hair wet from lust, arms and legs entwined,
braced for the next trip to the afterworld,
an Egyptian mummy whose linen wrappings,
the best that money could buy,
have entombed us.
I have singled you out in your casket there,
The dead of God RA, wherever we are in this world,
humanity to be pitied like the lost star,
that one star within the galaxy of our bruised hearts.
I will come to you dressed for the Kill,
We will ask each other our age, our occupations,
Our history in marriage, our health,
And, O yes, if not well,
then quietly we must decline the dance…
Yet you looked so happy that first time
We met upon the dance floor of this life,
How you still take my breath away
without the moonwalk of desire here upon the beach,
you and I stranded like dying whales upon the sands
of this nonchalant universe.
 Luis Lázaro Tijerina

Brotherhood of Pawns

When those in the crowd are sitting around,
And the air is empty,
And the sounds of the room
bounce about like a pinball machine,
It is all the same brotherhood of pawns,
Whether you get that girl
Or you sleep alone.

Among this crowd moving around,
I see those inside out
Upside down
Drop-kick's call of
"Gimme a cross and I'll drag it thru town!"
Find a reason to jump the train that derailed
In hot sulphur prayers on this night.

Among the pawns of brotherhood,
My only crime:
That crooked face,
That lazy pace burning along a trail,
An arson lighting up the night....
Fireworks, the engine on a ship.
My space among the brotherhood of pawns,
My space - that ambitious disguise,
The sky before the brotherhood of pawns,
Elations, partitions, admissions given as some
Kind of beautiful offering.

The drive that swings cuts you loose,
Kiss that mirror that hides your face,
Throw it off The Brooklyn Bridge!
Whisper, so no one else can hear,
Those words that hold you tight as you
Throw it off The Brooklyn Bridge.

 Ryan Fauber

Piano Recital at a Ratty Upstate Coffee Shop
Charles Watts

Comparisons of course
Are odious, but at what other
Table do you see a short skinny
Slick headed old grey beard
Sitting as lone representative
Of all that is masculine
Surrounded by five beautiful women
All tender and chic, allure in bloom

Look there, three zirconium encrusted hags
Look there, four hog gutted golfers
In running shoes and black socks
Polo shirts tucked into plaid
Bermuda shorts with woven belts
Look there, a maiden, virginal and alone
Staring enrapt across the baby grand
At the hoary pianist, a wilted Frenchman

Fingering Debussy and Wagner,
Bach and Ravel and Paganini
Behind him, a poster from a concert
Thirty years ago, when he was a
Young and handsome man
Surrounded by five beautiful demoiselles
Playing on a candle lit Steinway
At some café on the Left Bank of the Seine

Dogs bay at the cornflower moon
Where are you?
Wrapped up in red on the other side?

Remind me how to dream
The kind of dream where I can turn dust into beaches
Rags into sunbathers
The branches of trees jingle, magenta wind chimes

Then I will run to you
To a place I know you'll be
And this time
I won't be afraid to tell you in the morning
That you taught me how to dance last night

Jennifer Campbell

PABLO NERUDA WRITES AN ODE FROM HIS GRAVE TO CELEBRATE THE CHILEAN FOOTBALL VICTORY AT THE WORLD CUP, 2014

In my grave not far from the tides of the sea,
Here, no freedom exists but the worms
and earth fighting tooth and nail
to enter my poor casket,
Here, I celebrate the victory of Chilean footballers
 over the graveyard of the Spanish players,
Who succumbed to defeat on the manicured grass
 of Estadio do Maracana,
Where shouts of the Chilean people drown out
 beautiful songs of Samba and Bossa Nova
 on the white beaches of Rio.
Here at Isla Negra, my bones rot for sure,
But I heard there is a Fútbol Coach who wrote
 La bola es la libertad.
 Luis Lazaro Tijerina

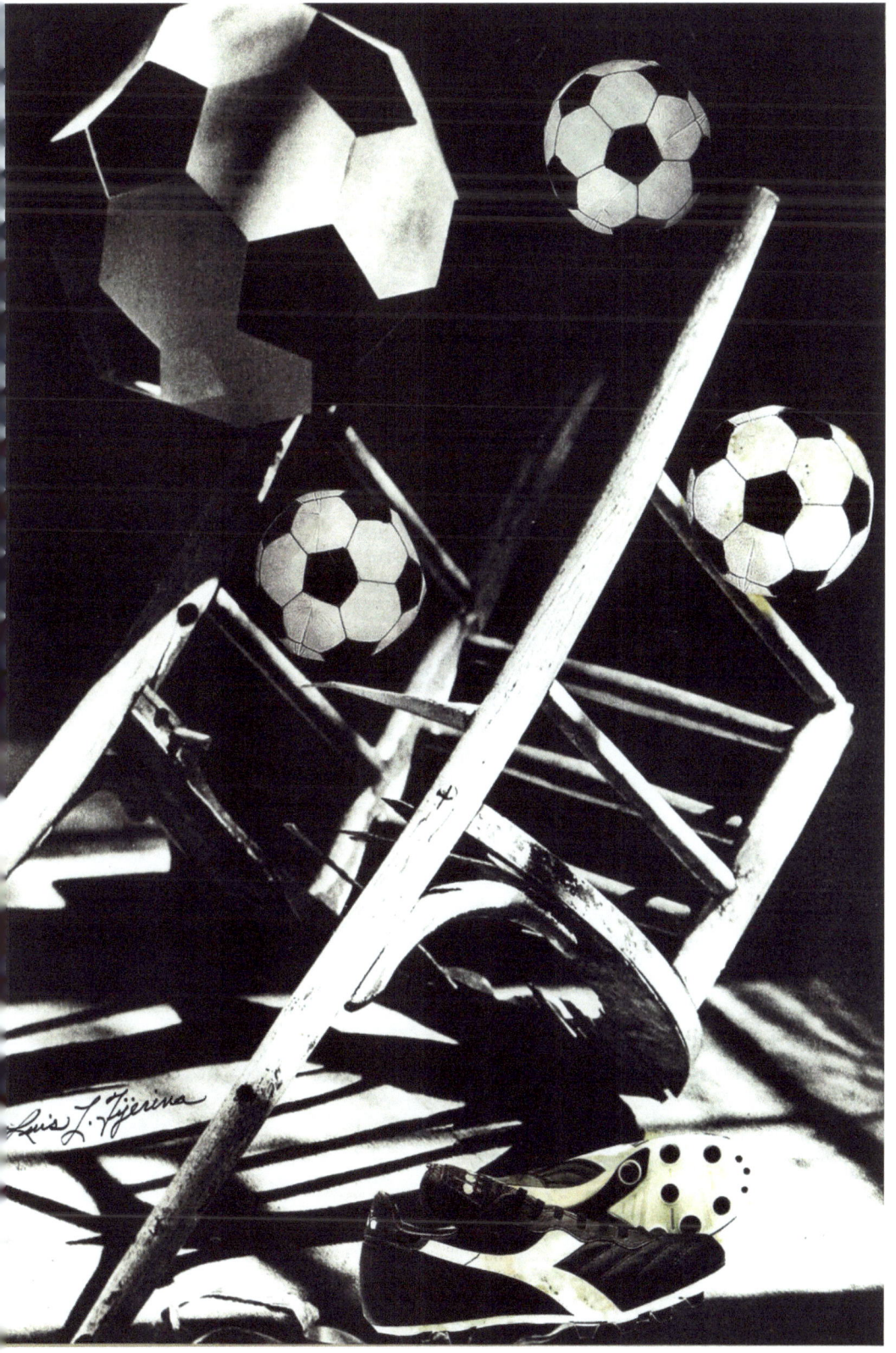

The temptation to secede and bleed into oblivion
melts beyond my being, out of the realm of possibilities
for the time I have remaining.
The minute hand ticks onward,
etching away my embedded mishaps
and carving a new name
for what I do not yet conceive to be mine.

It's not every day I walk in His holiness
Every blessing brings me forth,
into the profundity of that
which cannot be condemned,
but received with grave dedication.

My miraculous knowledge comes from farther
way down the long line of witnessing relatives,
pursuing my core in its ethereal beauty,
and gnawing at the internal structure
of complete and utter ingenuity.

I struggle and collapse and welcome the recompense
as it enters now, curious and unfamiliar,
definable in its legality,
totally starstruck,
abrupt,
maniacal in propriety.

I know not the meaning of courage
as it only seems to wander its way in and out
under the dominions
of monochromatic biology
and skyrocketing individuality.

I seek and betray,
surrender and slay
this crashing brutality of unimaginable reality
that every
one
passes
and
always
fails
to see

alissa gamberg

Franz Kafka in Prague

Lost and lonely
the tramcar
rattles his nerves
through side
streets of city.

Wonders
if man in dark
suit behind him
is following him.

Worries of sins
possibly
committed and of
punishments
only bad dreams
could invent.

And what of his
cramped
apartment and
the hideous life
forms that nestle
in the cupboard
corners and
cupboard shelves.

Lost and lonely
the tramcar
rattles his nerves
through side
streets of city.

Dave Donohue

ODE TO CUDDLING AND SHRINES AND OTHER HOUSEBROKEN THINGS THAT FLOAT LIKE A BUOY IN THE SEA

justin grimbol

Shrines
Are important
Especially
When they are held
Together by
Duct tape

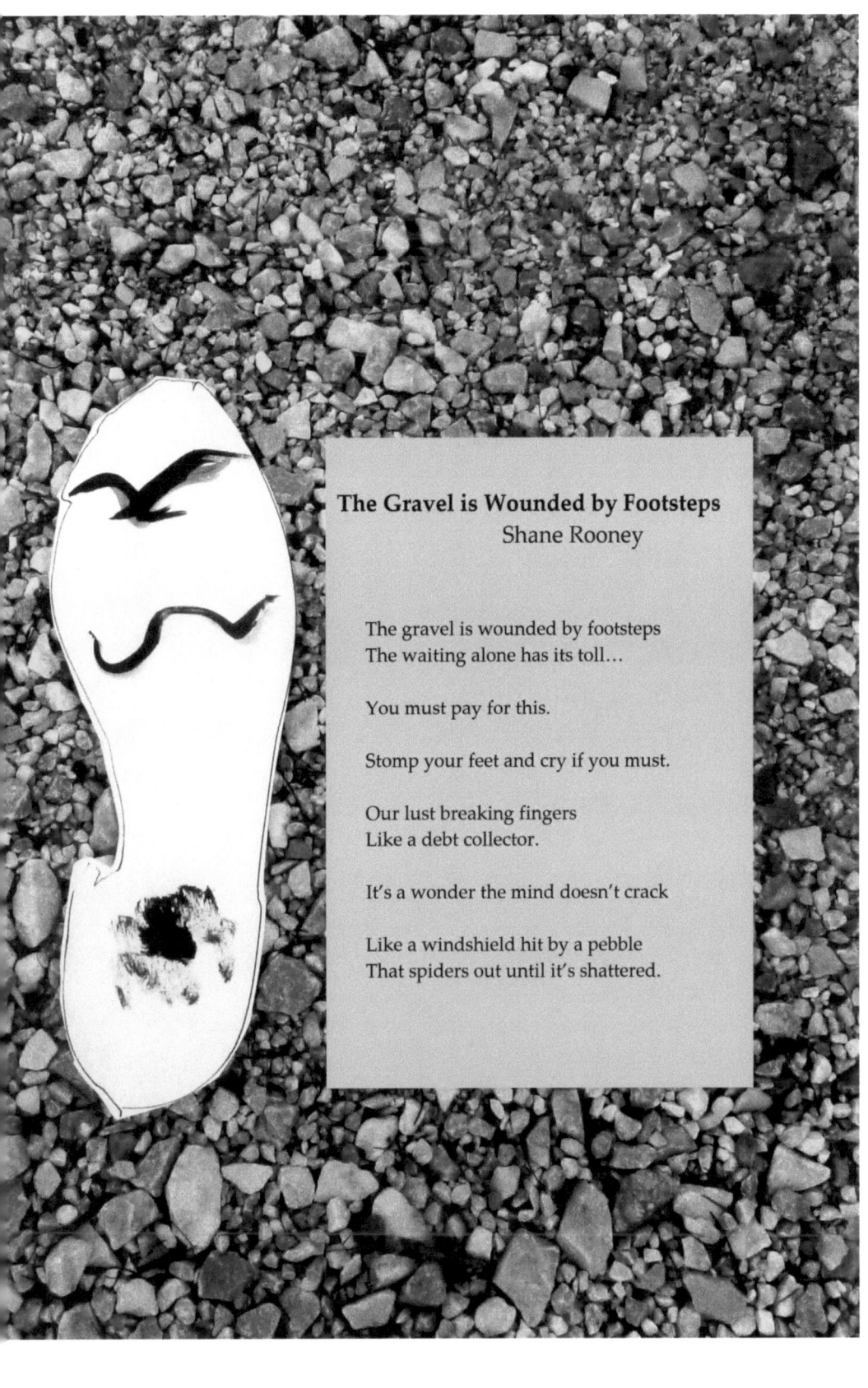

The Gravel is Wounded by Footsteps
Shane Rooney

The gravel is wounded by footsteps
The waiting alone has its toll…

You must pay for this.

Stomp your feet and cry if you must.

Our lust breaking fingers
Like a debt collector.

It's a wonder the mind doesn't crack

Like a windshield hit by a pebble
That spiders out until it's shattered.

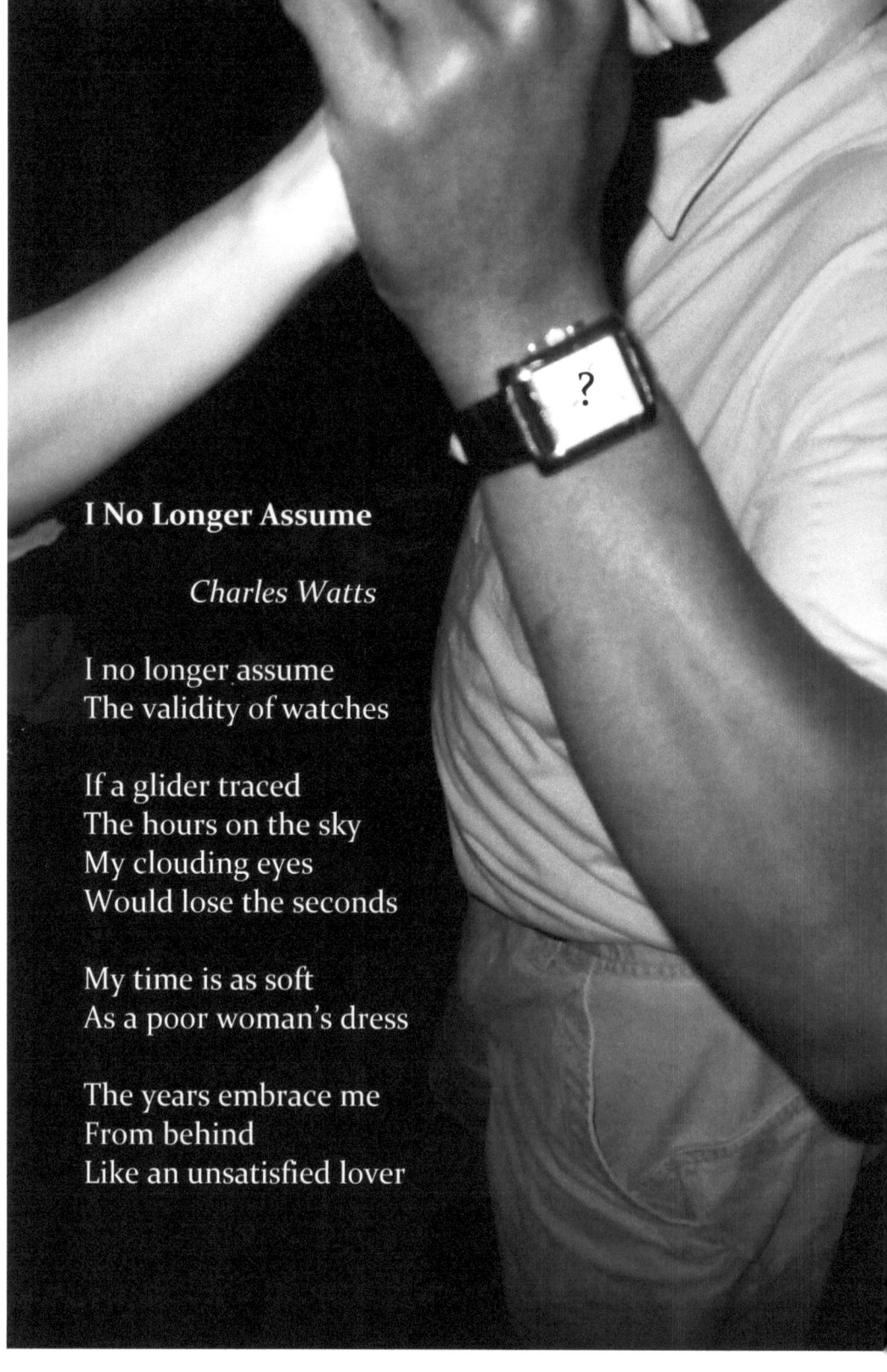

I No Longer Assume

Charles Watts

I no longer assume
The validity of watches

If a glider traced
The hours on the sky
My clouding eyes
Would lose the seconds

My time is as soft
As a poor woman's dress

The years embrace me
From behind
Like an unsatisfied lover

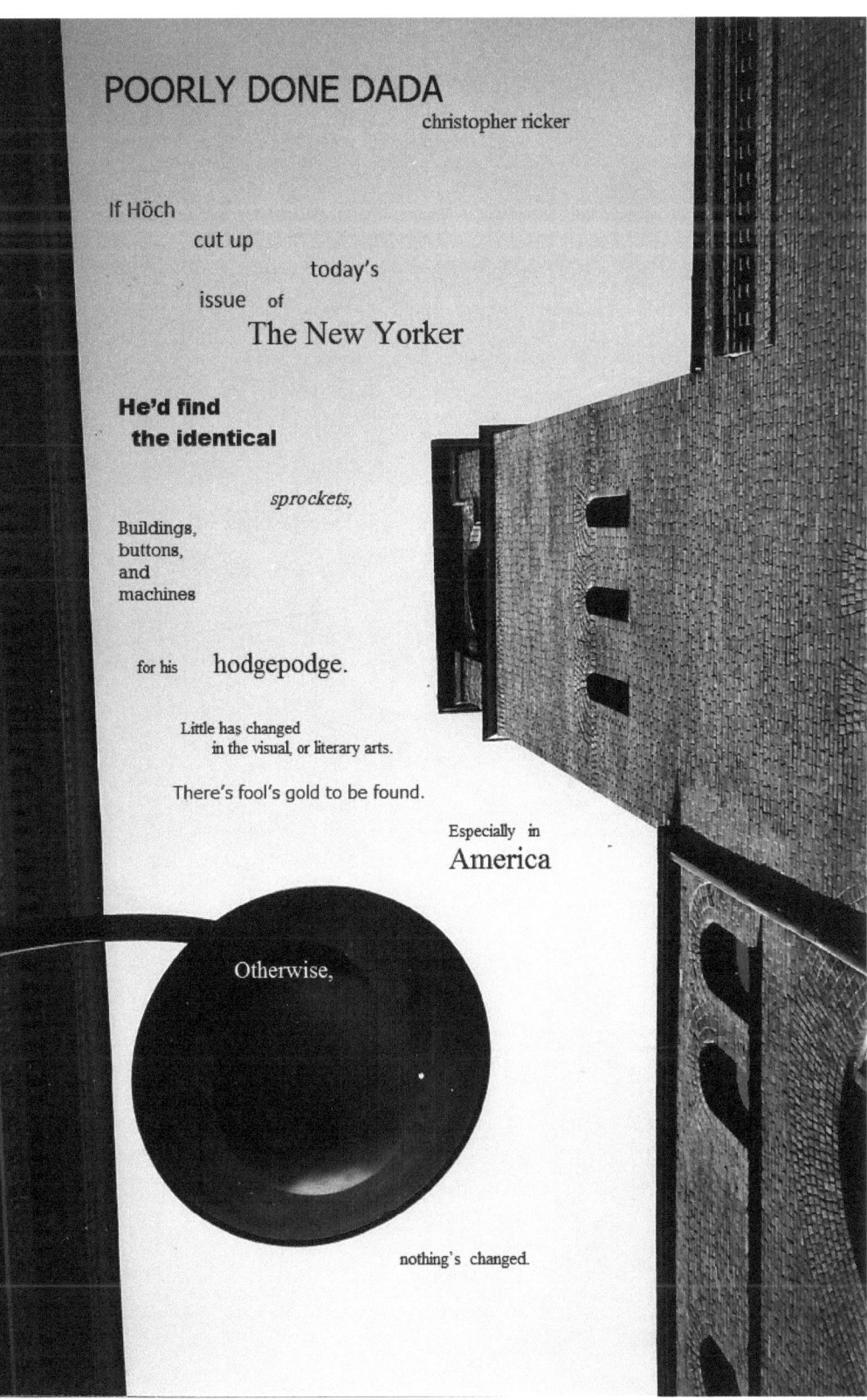

POORLY DONE DADA

christopher ricker

If Höch
 cut up
 today's
 issue of
 The New Yorker

**He'd find
the identical**

sprockets,

Buildings,
buttons,
and
machines

for his hodgepodge.

Little has changed
 in the visual, or literary arts.

There's fool's gold to be found.

Especially in
America

Otherwise,

nothing's changed.

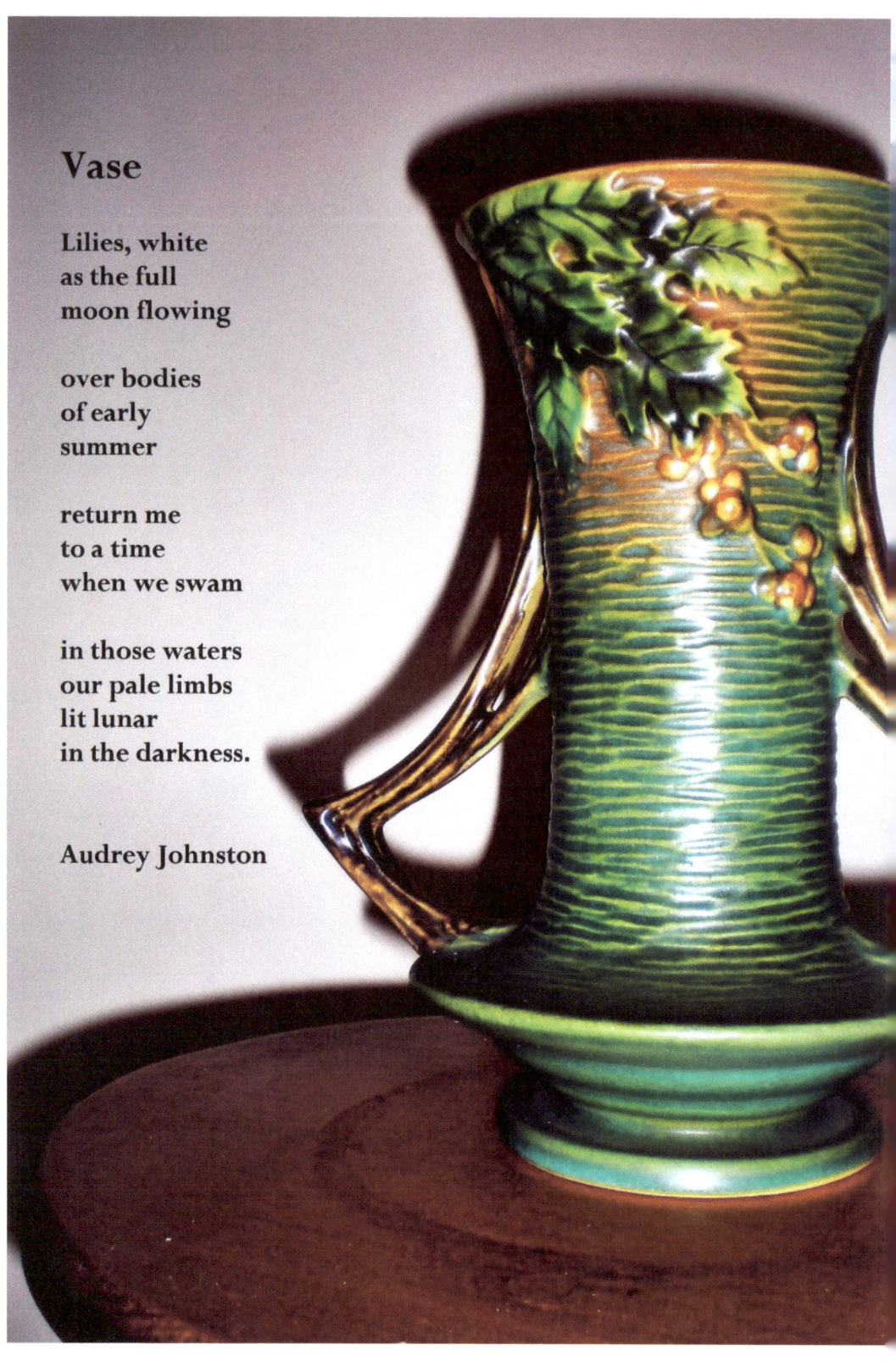

Vase

Lilies, white
as the full
moon flowing

over bodies
of early
summer

return me
to a time
when we swam

in those waters
our pale limbs
lit lunar
in the darkness.

Audrey Johnston

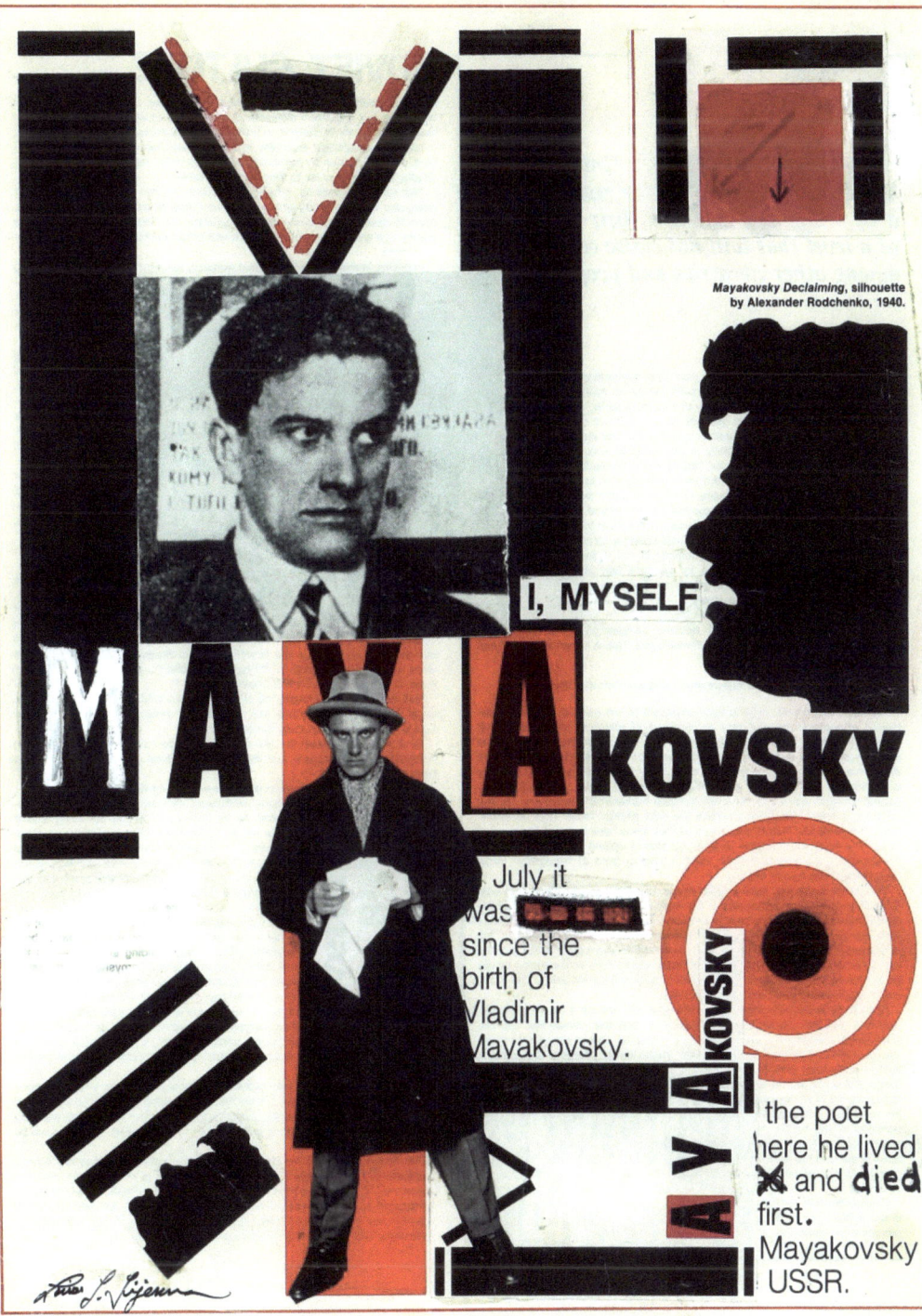

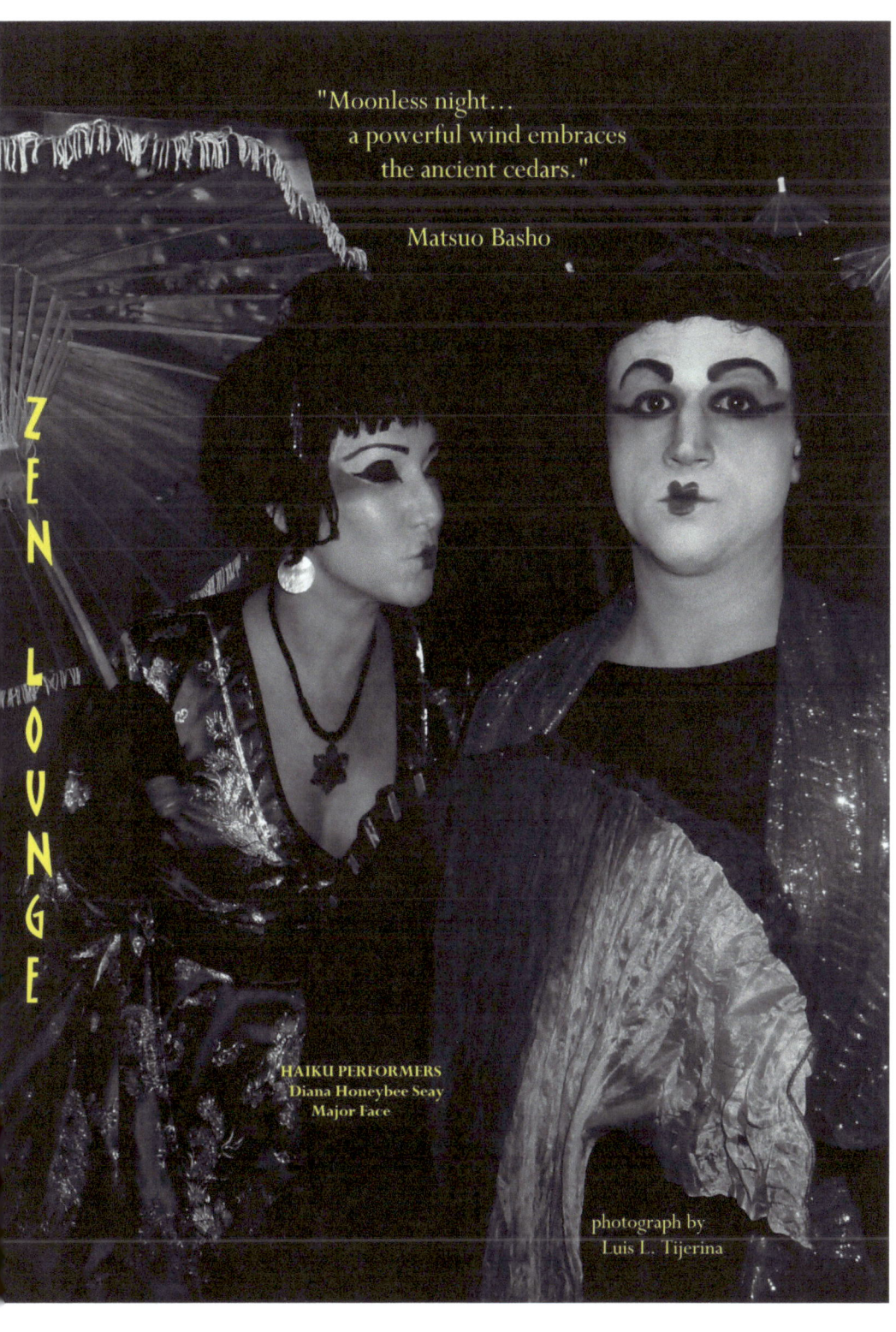

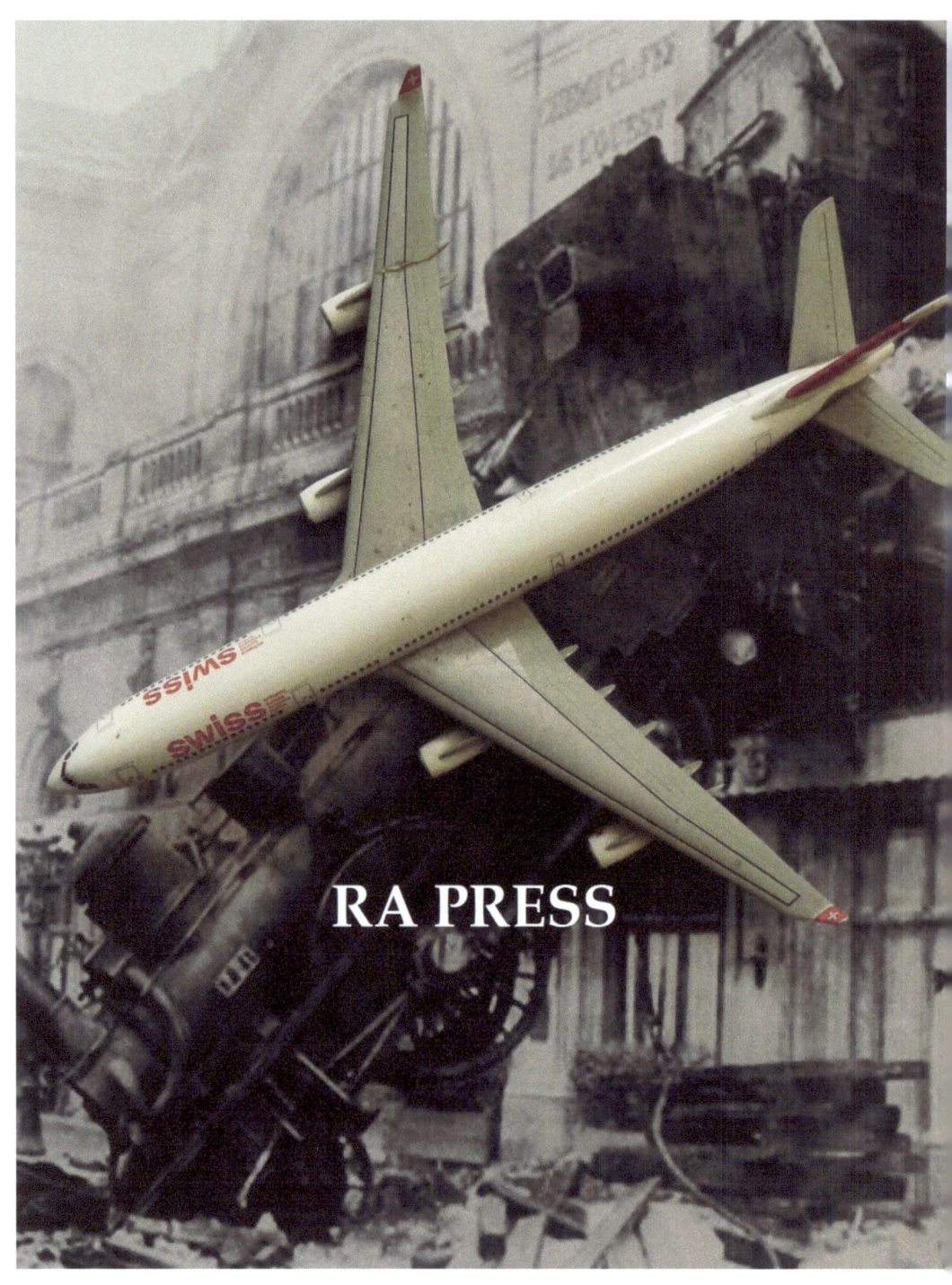

RA PRESS

ISSUE # 2

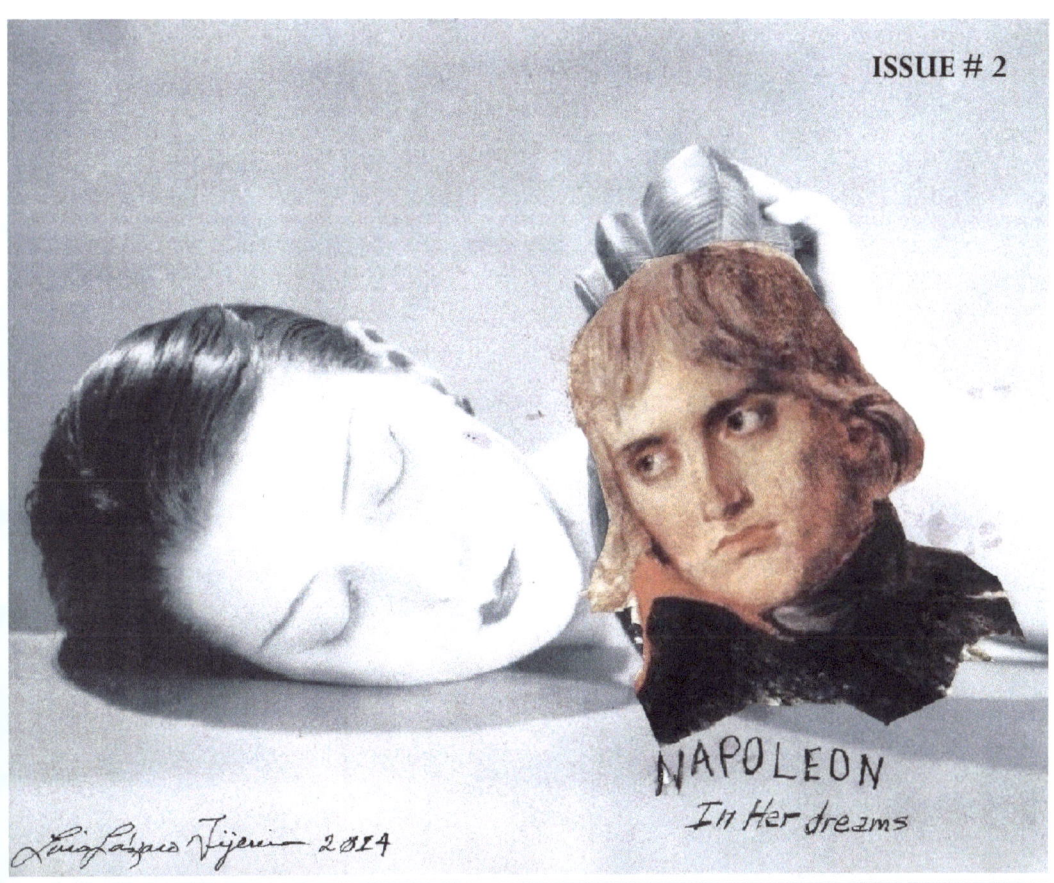

L'AMOUR FOU

JOURNAL OF THE SURREAL

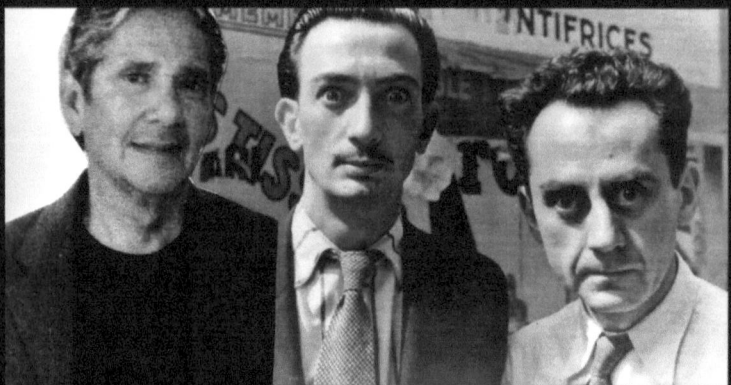

TIJERINA DALI RAY

THE SURREALIST TEAM

L'AMOUR FOU
ISSUE # 2
Ra Press
100 Kennedy Drive #53
South Burlington, VT 05403

ARTISTIC DIRECTOR
Luis Lazaro Tijerina
LITERARY EDITORS
Dave Donohue
Charles Watts
Christopher Ricker

CONTRIBUTING ARTISTS:
Chiara Stratton - Illustrator
LOVE OF GRAVEYARDS
www.chiarastratton.portfoliobox.me
dylandeathwater.tumblr.com

Leslie Walch
Surrealist Manifesto photograph

THERE IS NO PEACE
Charles Watts

The night is thick with proverbs
Each corner reflects
The sermon of the streetlight
 A rat's moonscape, cratered
 With cars and people

A building winks at me, the gutter
Flows, confident of
Apple core and orange peel

Ash cans wait
Omnisciently, hands out
Grey robed monks begging a meal
They know
There is no consolation
 In knowing
 There is no peace

www.rapressrafilms.com

21st Century Surrealist Manifesto
Charles Watts

The original surrealist movement was the bastard child of Andre Breton and the last dead Dadaist, who shall remain unnamed but suffered from dementia and thought it was still the 30's and Spain and Hemingway were coming to dinner. Surrealism's spawn includes Dali, Rimbaud, Tijerina, Donohue and Aragon, and its progenitors the Marquis de Sade and Dante. It traveled through dreamscapes and escapes and eventually became a corpse inhabited only by folks who agreed with its manifesto. All others were considered anti-irrational materialist deceptionaries and were cast out as the movement became rancid, like a religion after the prophet dies.

Depending on your favored etymology, "sur" can mean on top of, sour, south. "Real" means not false. The New Surrealist casts off the dogma of the past and embraces an unseen capstone, the sweet and bitter taste of life beyond the bounds of meaning, the preposterous reality that hides out of sight, south of an ice-thin shadow slung by an underlying chaos over the inert body of the socially acceptable. The only thing the New Surrealist rejects is everything the sagacious and balanced mind accepts as true.

excerpts from MEMOIR OF PARIS
Luis Lázaro Tijerina

RADINSKY

I once stole a coffee cup from *La Rotonde*, and it was Radinsky who assisted with the caper. He considered stealing a cup from this famous café to be a major heist and was all the more excited about it. Even Judith, with her upper class mores, participated in the theft. We paid our bill with smirks and then began to sneak very stealthily out the door and through the streets to the site of the statue of Balzac. But once at the statue's side, Judith suddenly became furious! Just imagine seeing a sophisticated, upper class beauty from Pittsburgh holding a knapsack, a purloined coffee cup stuffed within, while a Texan and a Mexican-American from Kansas stood by in fear that the French gendarmes would suddenly seize them and haul them off to jail!

Radinsky and I calmed my wife down and I promised her the best night in Paris that I could afford. Judith's face took on a wondrous expression, a glow in anticipation of the evening's awaiting possibilities in this City of Lights.

QUEHEILLE

In our romantic and playful escapades, Judith and I would swing over to *La Rotonde* to have our morning coffee or espresso. It was a special place for us, because there was a special man at the cafe that we enjoyed seeing, a waiter who went by the name of Queheille. Judith and I would sit at a little white-painted table outside the main door, and Queheille would come up to me, and with a slight smile on his face would say, *"Senor Tijerina, le café ce matin, ou peut-etre vin depend ce matin del' etat du monde ce matin!"* I would start laughing, while Judith, a reserved and proper lady, would just roll her eyes and, ever so slightly, smile.

THE WORKS OF KONSTANTIN MURAVEV

the art of geometry

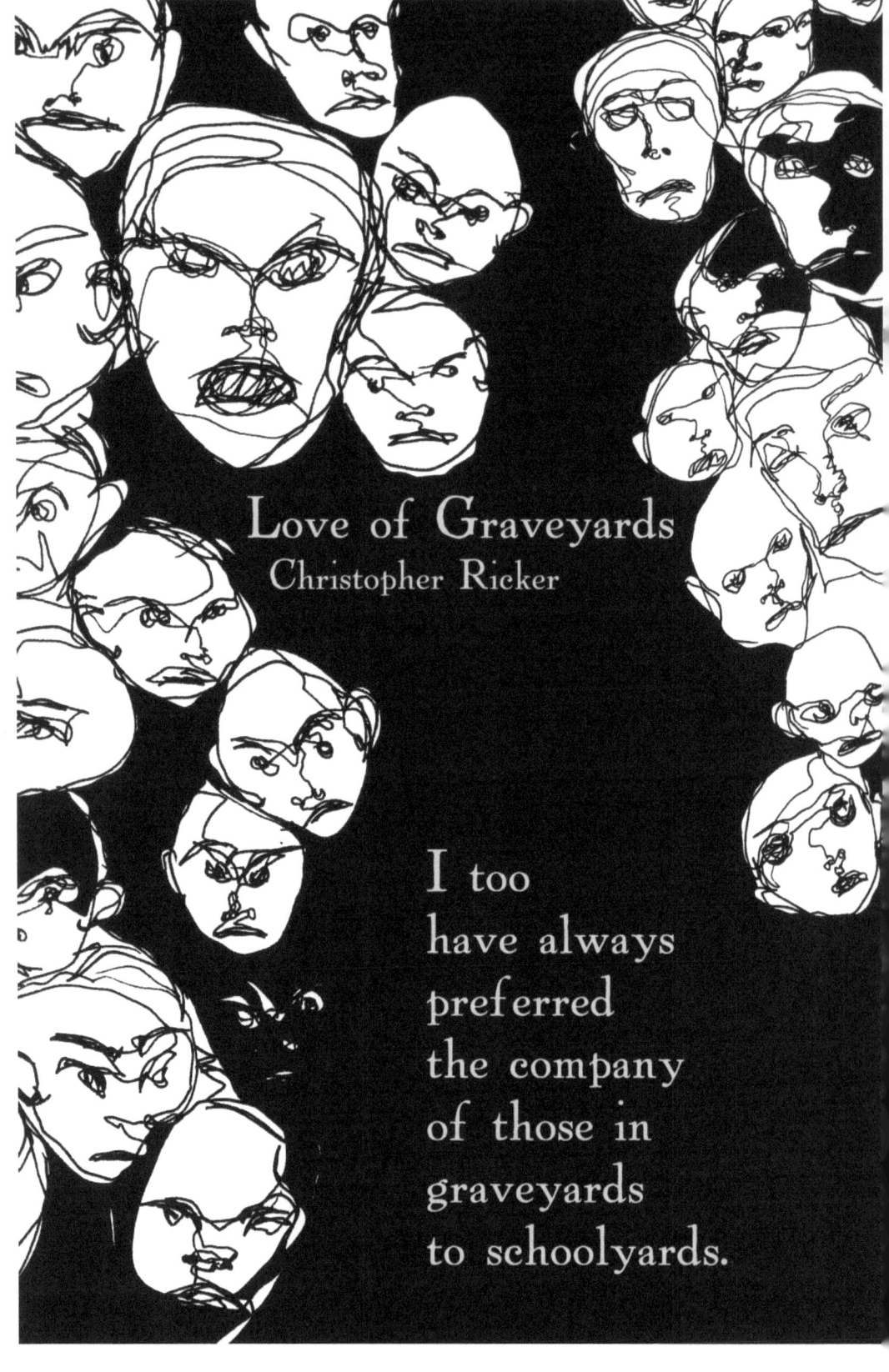

ALEX KREICHMAN

APRIL AND BULLETS ARE THOUGHTS

On a glowing
ember evening, air lint dry,
six travelers set out searching,
some to become one with reality,
others to try to escape it, and still
one who only ever thought to do what
his father and mother didn't approve of.
Most don't remember the date,
only that feet and minds diverged under
shadows of sprouting spring, leaves shading
Earth like a Pharaoh under Egyptian sunlight.
It was night time. One balanced on ground's growth
horizontal, on a tree no thicker than his own neck,
jutting out, reaching North towards Connecticut as if
there was the sun and salvation waiting, somewhere past
where the sky met the tips of hills and buildings,
and suddenly realized "This is the last thing my mother would
want me to be doing, and this will stay with me 'til the will of the world do us part."
He thought, balancing his life on a twig, of leaning over the railing of a glass elevator
with his grandpa behind him when he was too young to remember,
his brain debating whether this had been a night terror, like the time
raptors found him hiding behind the fire place of someone else's home,
or a fond memory he was too old to remember. He thought of leaning
over the railing anywhere with an escalator, and had to tell himself
he felt safer here, without a mother screaming "GET DOWN!"
surfing over a cliff on this outstretched limb
above the strophic sound of salt water waves,
each curl crashing on cue with a new voice
the same surname. He felt the weight
of his soul in his hands, like a loaded gun
to his head, nothing lying between what
he sees now and what he will see next
but the force of gravity and a few grains
of sand. Then a friend says "let me try,
let me stand where you are."
So one stepped off his kneeling tree,
and put the gun in his hand,
and wondered what thoughts the barrel
would plant past his temple.

PARIS IN MOURNING

"There they were, dignified, invisible…"
T.S. Eliot

Midwinter in mourning Paris,
The Seine frozen in grief,
Sodden rain on the streets where assassins
and artists like shooting stars collide,
A cartoon of human fire and wind,
The heart's blast from a Kalashnikov round--
A pen line of blood.
Paris in the month of blood and snow,
Paris where the rot in us turns
into steeled features of the forgotten,
Those who perished in the arrondissements :
in hovels without heat, without dignity,
without hope for the coming spring,
or those who perished giving a drawing
on the tyrannies in our time.
But this thing is true, where the dead lay,
There we lay also; yet, for the phrases of Paris
are the lights shining like
the eternal sun,
The Eiffel Tower a lighthouse overlooking
the living and oppressed, The Bastille's liberation
is the pen's words reborn with courage

.

Luis Lázaro Tijerina
January 8th, 2015

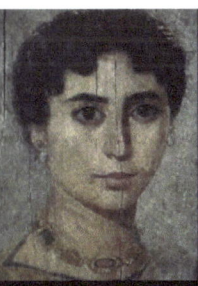

HYPATIA OF ALEXANDRIA
(To Sofie Richardson)

"He who influences the thought of his times, influences all the times that follow. He has made his impression on eternity." --- Hypatia

Mathematician and astronomer,
Hypatia outlived her time.
The daughter of Theon, the philosopher,
It was he who remembered and wrote down
her great words there in Alexandria,
that beautiful city of lust, words, and street cafes,
where even now the people gather there
in that city as Egypt smolders in revolt.
There in that city, she lost her life, stripped,
skinned alive and stoned with oyster shells.
Such is the world, when a great woman
or a great man thinks to be rational
in ending a dispute between warring factions...
Her death at the Church called Caesareum,
A Christian mob killing her in the heat
of the morning,
as the people of Alexandria awoke...
The sun coming up with its light of indifference.

Luis Lázaro Tijerina

"What are we waiting for,
assembled in the forum? The
barbarians are due here today."

C. P. Cafavy

NIKOLAY KULE: IMAGES SUBLIME

NIGHT WALK ON PESTEL

A COMPLETE CALM

BOTANICAL GARDEN
SOMEWHERE IN
CATALONIA

Four Thaiku
Charles Watts

1.
freedom is beyond
the mud wall and wood fence
that imprisons me

2.
mist rusted sunset
sheaths the eastern mountain tops
temple bells weep blood

3.
rising sun beats down
footprints on new fallen snow
butterflies drift north

4.
gloved hands cannot pluck
the strings of my lady's harp
snow sinks branch to branch

photograph
Pat Farren

Hike to Sunfish Pond
David Crews

The drifting cries
of the hawk silhouette
slip in and out
of the tree line
somehow
through red maple
and across the afternoon
where huge white
gray clouds slide
from sight
to consciousness
not present enough
to remember
but startling enough not
to forget each day
that slowly circles
in and away.
If someone could turn
the sun's cracked
light into rain
we'd have a song
worth almost
two growing seasons.
Each step plants
firmly in the dirt
more stationary
than ever. And all
that's temporary
moves around
the body
and withdrawal
which grips it.

davidcrewspoetry.com

NEAR A POND

Christopher Ricker

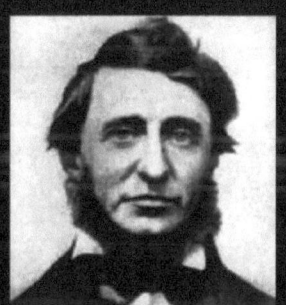

"I heartily accept that motto still—,"
said the ghost of Thoreau.

It was twilight. The descending summer sky mingled with the sacred waters of Walden. Stars and fireflies began to appear in the heavens and on earth, regardless of our transgressions.

Mr. Thoreau wore a withering expression that ran the angular measure of his face. It was a most worrisome look. Thoreau always became dour whenever he gazed upon the parking lot.

We journalists and poets had very little time left. I, in particular, needed something concrete in order to finish my assignment, and if I didn't gather information this night, it would be another year before I would be able to meet with Mr. Thoreau again.

The mosquitoes must have felt my anxiety because they refused to bite.

"Mr. Thoreau..."

"Please, call me Henry."

"Okay... Henry, I am working for a magazine and am here to record your thoughts on the status of literature. I understand this to be a rather nebulous question, but please, whatever you can tell me... a favorite book, or poem, anything... would suffice."

Mr. Thoreau stood and walked to the edge of the pond, hands on his hips. His silhouette resembled a captain on a ship. "I've always preferred the classics," he replied severely. "Works in Latin, to be sure. You understand, there is a lack of sophistication in American literature, and in the whole of much of modern Western Literature. Writers no longer take responsibility."

He turned to me, while at the same time, stretching out his arms towards the pond. "You can often tell the health of an ecosystem based upon its primary species. I am, of course, speaking of reptiles, amphibians, invertebrates, etc... They are not the primeval ooze we once determined them to be. I believe the same can be said for human society - its painters, poets, musicians, and other artists. But, unlike a frog in a polluted vernal pool, artists have an ability to thrive, in a sense, amidst the crumbling madness. As the facets of civil community continue to fail, the artist, in my opinion, has a responsibility. This should be seen at the artist's core, if he or she is true."

In the dark could be heard a myriad of chorusing frogs and insects.

Henry summarized his theory of natural reflection. "I am ashamed that more poets are not involved in revolution. It's an primary factor for me - tells me if their work is worth the trouble of reading or not."

And with the last glistening of the dying light, Mr. Thoreau at that moment vanished back into the blackness of space and time.

How Can I Compare You?

"Pero esperame guardame tu dulzura"
　　　　Pablo Neruda

"Se t'hanno assomigliato"
　　　　Eugenio Montale

Valentina, you the legend of my house,
Hot bed of desire between us,
An imaginary coil of the summit of a moment.
You, that victor over winter, spring,
the autumn of my years now turned to summer,
because of you with that captivating shrewdness taking me across the
sludge years of the muffled steps of horror in our time,
Your voice that great foam of life
coming out of the seas. You, grasping my arm
from the terror that is in us.
Those almond eyes of yours destroying a bank of snow
melting into the Voronezh River,
Your red plum mouth, your face like an oval ivory shell,
That silk hair of yours like great seaweed
scrawled in my memory, as I climb the stairs,
Entering a room without you.
I cannot compare you to the gentle wind
murmuring in the summer time, for your gait,
Your voice trembles ever so slightly against
my shoulder,
When I think of you before tomorrow.
We, those Capricorns moving across a street,
Where the great blood in our veins
beckons us to work our hands into wood.

　　　　　　　　　　　　　　Luis Lázaro Tijerina

　　　　　　　　　　　　　　dedicated to Valentina Chursina

shane rooney

seasonal reflective disorders

In August I thought we shall be a grave

In August I thought we shall be a grave
In December I thought the light was a boring thing
In March you groped inside me.

An abandoned life left inside
The mire of many chances missed.

But eggs hatch
And things commit to life
Or break like lambs at the resurrection.

Open the stony yolk
What will you be
Is inside that tiny clot.

My words know the limits
Of living

Like a bird flying into glass
Head concave from the deceit

Of a window kept too clean
Of dirt.

Nashua in Winter

It's clear your hands are cracked
And curb lay in the street like broken limb.

Your face pasty with salt
You eat like a mother pregnant with five.

I haven't harmed you yet
Nor you me

But this gray day
I feel surly with gin.

And your brake lights
In front of me

Sends rage
Gurgling down my throat.

SE ENCUENTRAN LOS RESTOS DE MIGUEL DE CERVANTES

Demasiada cordura puede ser la peor de las locuras, ver la vida como es y no como debería de ser"
 Miguel de Cervantes

"Las palabras no fueron dadas al hombre
 para ocultar sus pensamientos"
 José Saramago

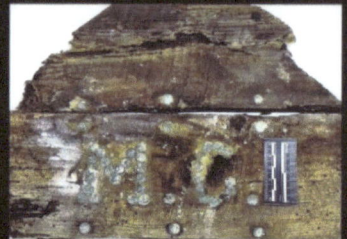

Huesos de los muertos en ese convento español,
Donde las monjas descalzas alguna vez vivieron,
Allí los modernos encontraron sus huesos descarnados, Él que luchó
en la batalla de Lepanto,
Ese autor español único que cambió al mundo
con palabras e imágenes de molinos de viento y risas,
Don Quijote, aniquilador de dragones imaginarios de este mundo,
Pero qué hay de aquellos que perecieron por el dragón en España,
Sus restos del pelotón de fusilamiento aún ocultos
en tierra española.
Esas grandes iniciales "MC" del tamaño de un dedo formando parte
del deteriorado ataúd de madera destrozada,
El ADN confirma que ese gran hombre estaba en la cripta,
El aire se agita incluso cuando la puta guerra mata
en Alepo, Donetsk, Irak y Nigeria.
El Barrio de las Letras nunca será el mismo,
Yo tomo mis propias humildes palabras a las calles
donde los vivos viven sólo una vez.

 Luis Lázaro Tijerina

Translated by Sergio Ricardo Melesio-Nolasco,
with the collaboration of Alissa Gamberg,
March 18th, 2015

REMAINS OF MIGUEL DE CERVANTES FOUND

"Too much sanity may be madness and the maddest of all, to see life as it is and not as it should be".
 Miguel de Cervantes

*"Words were not given to man in order
 to conceal his thoughts".*
 Jose Saramago

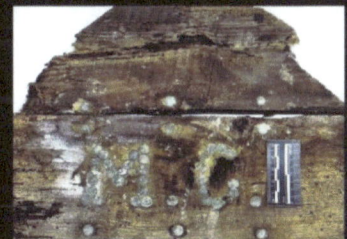

Bones of the dead in that Spanish convent,
Where barefoot nuns once lived,
There the moderns found his scarred bones,
He who fought in the Battle of Lepanto,
That one Spanish author who changed the world
with words and images of windmills and laughter.
Don Quixote, slayer of imaginary dragons in this world,
But what about those who perished by the dragon in Spain,
Their remains from the firing squad still hidden
in Spanish earth.
Those great thumb-sized initials "MC" forming part
of the tacking of a shattered wooden coffin,
DNA confirms who the great man was in the crypt,
The air is shaken even as the whore of war kills
in Aleppo, Donetsk, Iraq and Nigeria.
Barrio de las Letras will never be the same again,
I take my own humble words out into the streets
where the living exist only once…

Luis Lázaro Tijerina,
Burlington, Vermont, United States

BOTH BY BURKE

Wayne Burke

Fragile

I brush my teeth
with boric acid,
shave my ass
and walk backward;
watch lunatics pick
through garbage;
everyone I know
is serious as Ebola;
I'm stuck on the road
less traveled;
send my letters
marked FRAGILE.
When alone I bottle
dew and play
with my marbles.

The Important Thing

is that
a permeable membrane
be established -
a kind of porous defense,
no iron dome
or steel curtain
but a picket boundary
that allows for
seepage
or
the creeping tendril
vine
winding
toward heart-struck
anti-chambers
of our designs.

"We don't see things as they are,
we see them as we are."
Anais Nin

www.ingramcontent.com/pod-product-compliance
Lightning Source LLC
Chambersburg PA
CBHW041116180526
45172CB00001B/270